Other Works by the Same Author

Angel's Passage

The Franciscan Conspiracy

Mystic Mountain

Trappist Tales

The Wolf in Winter

Yearning for the Father

Leaving My Broken House

By

John Richard Sack

CyberScribe Publications

Copyright © John Richard Sack, 2016. All rights reserved

No part of this book may be reproduced or transmitted in any form or by any means, electronic or mechanical, including photocopying, recording or by any information storage and retrieval system without permission in writing from the author. Address inquiries to:

CyberScribe Publications
P.O. Box 271
Jacksonville, OR 97530

Email: cyberscribe2@gmail.com

ISBN-13: 978-1533123930
ISBN-10: 1533123934

Introduction

The *haibun* is a literary form that balances prose and haiku poetry (in both its regular and irregular forms). The classic examples of this joined form are the poet Matsuo Bashō's travel notes, written in the late 1600s. See, for example, *The Narrow Road to the Deep North and Other Travel Sketches* in which he describes not only the landscapes, shrines and people he met along the way, but also the spiritual pilgrimage advancing simultaneously within. Referring to Komon (Kuang-wên), a Chinese priest of the Nansung dynasty, he wrote:

> *Like the priest of olden times who traveled*
> *countless miles and cared not for*
> *his rations, and who found ecstasy*
> *in the pure light of the moon, I am leaving*
> *my broken house on the River Sumida ...*

In this same spirit, Sakujin (*Evolving Man*), following his awakening some 300 years later, wandered through southern Oregon — a region nostalgically similar in its seasons and rugged topography to his beloved Japan. In *Leaving My Broken House*, he records the first year of his journey.

Leaving My Broken House

Nicolae Tonitza, Managalia

Winter

In the midst of a rainy winter I find myself on the edge of the western world — a beach below Cape Blanco, Oregon. The southwest wind vents its fury on this unprotected stretch of coast. The ocean bellows and churns with foam, a chant and dance it has practiced for countless ages, but all its fierce endeavor ends in delicate spray curled across the sand. Here, where the land begins and ends, I've stepped forward on this New Year's Day.

The masters say each place in every moment is where we are meant to start, in a universe renewed at every second. The sunrise is hidden this specific instant in shrouds of cloud and vapor rising from the tops of evergreens. The heavy air mutes even the gulls. They wheel ghost-like through the fog, seekers like me, although perhaps more certain of their goal.

 I greet the New Year.
 Groping down an unknown road
 Cloaked in pilgrim's robes.

 Waves scour the sand —
 A clean slate
 This New Year's Day.

Sesshu, Haboku Landscape

I admire the primordial trees, gnarled gargantuan bonsai, tenacious in their grip on the sculpted cliffs. Some have finally surrendered, let go their hold upon the rocks and crashed to the shore below. Air currents moan through the cavities of rotted trunks, improvising preternatural sea songs.

> Tall firs lean like wheat
> Before they lunge, undone,
> To the earth's embrace.

> Whistling winds mimic
> The ancient chant of whales
> Through fluted tree trunks.

Turning my back to the gusts, I let them push me up the path to a battered lighthouse. The building is locked, but on its lee side I gain brief protection from the weather.

The rains, from downpour to drizzle, are constant in these dark months of the coastal year. Confusion and a sense of something lacking — a soul turned inside out by cabin fever — have forced me from my home and stove. With rain gear, tent, pack and walking staff as my sole supplies, I closed my cottage door and began this sojourn of the soul.

> Quitting his broken house,
> He launched into the somber
> Drift of winter.

I long at once for a wise and experienced guide, for I've no idea where this journey is to lead. A verse from the *Zenrinkushu* springs to mind:

> If you want to learn the path up the mountain,
> Ask the man who hikes it back and forth.

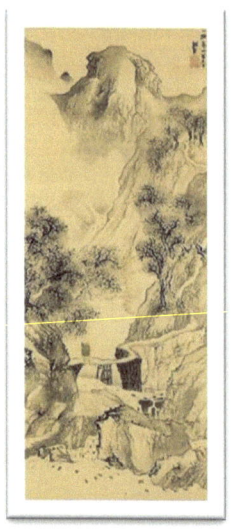

Buson, Landscape with Solitary Traveler

Will I return with snow-white hair, brilliant as the crown of Shasta's sacred mountain? Will I return at all? Many of the old ones died while on the road, trekking to eternity.

I find a trail that winds uphill to an inland slough. Here, the gusts are calmer with the cape and trees behind me as a windbreak. The marsh appears deserted, serene in its mantle of mist. By some such pond, Matsuo Bashō heard a frog kerplunk, opening a portal to the other world.

> *Furuike ya kawazu tobikomu mizu no oto.*
>
> An ancient pond,
> A frog leaps in —
> Deep resonance.

Deep resonance, indeed, if we focus on its Source. Don't be distracted by the ripples!

Does one waken always with a start, like Bashō in this poem, like Saul of Tarsus tumbled sightless from his horse? Or do such moments sneak upon us, softly stirring us from sleep? Is the Spirit ever groaning, begging graces for us even as we languish unaware? If I abide awhile in silence, this pool may burble up an answer from invisible depths.

> Soft rain nourishes
> The willow's thirsty roots,
> Despite the dark night.

But then the startling awareness …

Drowsy morning fog
Shrouds the silent slough …
Thunder of heron wings!

Who is more surprised, the bird or I? I am almost beside it when it lifts from a branch at the water's edge. In the custom of the native people of this coast, and far from my homeland's cranes, I months before had recognized the Great Blue Heron as my spirit guide. This sign, at the very outset of my pilgrimage, is auspicious. At once it seems, the sky lightens and the wind and rain abate. With a word of thanks for an unexpected blessing, I continue up the hill.

Beside a rutted, muddy road, I am hailed from a truck splashing in my direction. "Look at that!" the driver shouts, jerking backwards with his thumb. "I hauled him from New River not ten minutes ago. Took an hour to land." The fish

is huge, a sturgeon long as the rusted truck bed. "I'm taking it to town, to get its picture in the paper."

He offers me a ride. I remind myself that teachers are everywhere and each meeting is a chance to learn. I gratefully accept the lift. We pass a crossroads market and he tells me that he cooks for income, strums guitar for joy, and sings in the restaurant when the last meal's served. "Chef Jeff the Music Man." He lives alone by choice, admits he's prone to wanderlust, and always glad to help a fellow nomad.

My good angel cooks me breakfast — mushrooms, coffee, eggs and toast — at his cafe. His home is Bandon-by-the-Sea, a village at the mouth of the Coquille River. He asks me for a poem as payment for my breakfast, and I scrawl upon a napkin:

> The cafe singer
> Could compose a ballad:
> "Pickup Full of Fish."

Sleepy patrons stumble in for their first coffee of the day. In a corner, fishermen debate the safety of the bar where the river meets the sea. I feel a sudden sorrow for the men and boats this town has lost and for their widows grieving

on the shore. I pray this gusty morning that these men will turn back home to celebrate the New Year with their families.

> His trawler foundered
> On the bar. The fish and he
> Now sleep more deeply.

I thank my host again and wander to a dock near the cafe. At this early hour I find a solitary man seated at the end of the pier, meditating as the ripples whisper underneath. Stolid as a mountain, he pays no heed to raindrops. Between us is a maze of pottery and garden figurines.

> Winter drizzle
> Fills Saint Francis' folded arms
> To form a birdbath.

He ends his morning practice and flips a small stone into the lapping water. When he sees me watching, he explains, "Each day I drop a pebble in the river, here below the pier where it's ten feet deep. By the time the rock pile breaks the surface, I hope to have made a bit of progress."

He goes his way, saying he has urns to fire before he opens his shop. I nod to this patient tutor and take the plank seat he has just vacated. One must surely gain from sitting in a

space so hallowed from daily dedication. I toss a stone into the water when I finally rise.

After noon I cross the Coquille River, following the highway signs to Bullard's Beach. The park is empty this midwinter day and I raise my dome tent in a grove of sheltering pines. Misshapen boughs curve over and around it like the broken stones of a hermit's cell. The branches serve as my umbrella and remind me of a former meditation site, a bench within a copse of birches. The trees there leaned beside a pond where the single resident koi rose to the surface to inspect me. Her gaze and manner led me to believe she was an old soul, and I returned her greeting with a reverent bow.

Golden mother koi,
Will you teach me to see
Even as you do?

I wonder whether I might, in this private sanctuary, wait out the rains for several days before I leave again. My answer comes next morning when the park ranger wakes me, calling from outside my tent.

His name is Anders and after I explain my plan, he leads me to his manufactured home for breakfast. He tells me that the park in winter has few visitors and gets busy only when the schools begin their April break. If I will help prepare the campsites for these next few months, he will let me stay in one of the park's several yurts, wait out the winter in this solitary place and resume my journey when the wind shifts to the north. The wind shift spells the end of winter on the coast, the beginning of its only other season: the chill spring-summer-autumn months of morning fog and stiff north winds. Outside Anders' window, white-tailed does meander through the pines as we shake hands on the deal.

>Two men talk at dawn,
>With naught but steaming coffee
>Raised between them.

Buson, Two Men Talking

Rising each day in my luxurious yurt, I confess I am embarrassed to think of the tiny hermitage of the priest Bucchō behind Unganji Temple. In his *Narrow Road to the Deep North*, Bashō recalled his teacher's portrait of the place:

> Less than five feet square,
> My tiny cottage;
> I would happily leave even this
> If not for the rain.

Ah, I agree — if not for the rain ….

I begin each morning giving thanks for this astounding gift. When the dawn is dry, I sit upon a flat rock, part of a jetty that protects another vacant lighthouse. I see the potter on his dock, a speck on the opposite shore, and thus our morning meditations span the river. In a country so devoid of shrines, people must create their own.

> Seated below
> This darkened lighthouse,
> I awake to Light.

> Shadows shifting on
> The far side of the river.
> What lies hidden there?

In my daily round of service in the campground, I pick up storm debris and fallen limbs, saw broken pine and cedar branches into stacks of firewood for the summer and seal wounded trees with a tarry pitch. I also clean the campsites used by rare winter visitors. At noon I cross the bridge into the village, buy groceries and eat my main meal of the day. By evening I am on my stone ledge once again, watching the cormorants skim the river, fishing by twilight, disappearing into the dimming water when they spot a meal.

Back inside my yurt by nightfall, often with the rain drumming on the roof, I think of Lu Yün's "Valley Wind:"

> Living retired beyond the world,
> in silent joy in isolation,
> I pull the rope of my door tighter
> and block my window with roots and ferns.
> My soul is in tune with the spring season.
> In fall there is autumn in my heart.
> Thus emulating cosmic changes,
> my hut becomes a universe.

I bow to his genius, kindle a fire in the woodstove, and write a linked reply straddling the centuries and miles between us:

> Monsoons pound my hut.
> Flicker of cedar embers
> Gilds the barren walls.

The seasonal change is coming soon and, like Lu Yün, I tune my spirit to greet it.

> Ice on the inlets;
> Fish, motionless beneath it,
> Share a dream of spring.

Spring

For several months I live in the camp while my travels narrow to my near surroundings, a pilgrimage in place, a time of local exploration — but also quiet reflection that enlarges me beyond both place and time. The weeks press on, the minutes of daylight increase while the rains decline. Nonetheless, some days that break in sunshine end with me soaked when I've failed to read the signs of fickle weather.

> Rose-rimmed clouds at dawn.
> Surprise! A hail invasion!
> Never trust the south wind.

Each day, with my chores done, I roam the park and village, the headlands and shore. What I discover, for the most part, is lost time — learning, for instance, of the wailing ghosts, the innocents whose sad laments merge with the winds bristling through the camp. Fittingly, this education happens on one of those mystical mornings when fog softens the world, from the needles of the pine trees to the metal beams that span the river. I stumble on a strapping man in hip waders, his shoulders rounded as a boulder while he stoops and stalks along the river's edge, a few feet out into the water.

He is surprised to have a visitor in this deserted stretch, but greets me with an explanation. He is an archeologist, he says, seeking artifacts that speak of centuries past. He shows me the remnant of a fish weir, still anchored underneath the surface, a funnel-shaped basket that the Athabascans used to trap salmon returning from the ocean to spawn. In his pouch are spear points chipped from chert and schist that he has rescued from the mud.

Heavy-booted and just as heavy-hearted, he leads me from the water to charred sediment where once stood wood-plank homes. "The local tribe once lived on the opposite shore," he says, "but army surveyors rained cannon fire upon them from the bluff and the survivors crossed the river. They lived on this separate site peacefully enough until …"

His voice falters when he speaks again, "… until one hellish night when a mob of drunken settlers rowed across, shot them in their sleep and burned their homes. Not a man or woman, elder or child, survived."

> Fish weirs and middens,
> Vanished Athabascans
> Grieving in the trees.

The pain passes from his eyes. He recovers his voice, shakes his head and asks, "What do you think gets into folks? What makes them so hateful towards each other? What would drive them to do a thing like that?"

I have no answer for him, nor does he expect one. His lament is universal, defying explanation, an unfathomable question heard in every generation, even as the massacres continue in our time — always *us* against the *other*, the feared unknown one different from ourselves, always making two of what is one.

"These are not the only ghosts who prowl this park," he adds. "There are others in the dunes who once were sailors of another race, if the lifeless know of such divisions."

When the sun burns off the fog, I hike some miles north of the lighthouse, along the ocean border of the park. Finally,

I see fragments of a ship's hull protruding from the sand, with *Kanji* traces carved into a plank.

Anders fills in the story over evening coffee. "The boat was a junk, likely from your Japan, blown off course some thousand years ago. A native legend tells of a fearsome tribe of bronze-skinned warriors, skilled at fighting with

only their hands. They died out as swiftly as they came, though, for they had no women with them and never mated with the local people — gone with no

memorial but this tale and a bit of boat."

I recall tales of the Japanese river sprite. "They were *kappas* out of water," I suggest, "stranded on a foreign shore."

> What remnant will be beached
> When the teeming ocean ebbs?
> Starfish or a ship?

A boy fills his pail
With starfish torn from the rocks.
How will they survive?

Those early settlers have likewise passed, their only trace the tombstones leaning in the graveyard hovering above the town. At least these monuments bear their names. Many are familiar, carried down in local shops. Did these people suffer equally as the natives in their pioneer privations? Do they too linger near, seeking to retrieve the pieces of their scattered souls? Only fancy can imagine.

As for the earliest tribes, their only monument is a cluster of offshore rocks — the centerpiece, a face-shaped monolith whose gaze is fixed forever on the sky. The face, they claimed, is that of a haughty princess who rebuffed the amorous Moon God. She and her basket of kittens, strewn out in a trail of smaller rocks, pay the price of his unrequited love, frozen in time and space, forced to stare forever at the one she spurned.

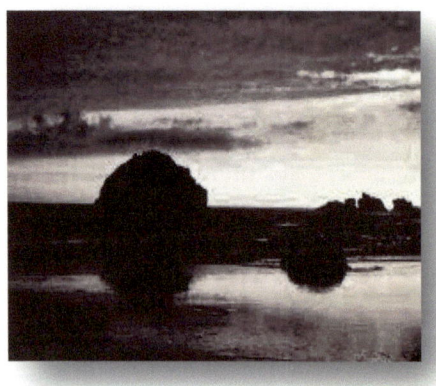

On the night of the March full moon, I straddle a log washed up on the shore and join her timeless vigil. I hope the Moon God isn't prone to jealousy.

Further up the beach is an even larger mass of offshore stone. It has the shape of an elephant's head and trunk with great fan ears, half-submerged beneath the turbulent surf. I wonder what the natives called this Elephant Rock, for they had never seen nor heard nor even dreamed of such a wondrous beast. But did they even need to put a name to nature's wonders?

The great religions claim salvation through their prophet or their avatar alone. Who, I wonder, saves those remote souls who have never heard nor dreamed of Krishna, Moses, Jesus, Buddha or Muhammad? Is not every baby born in the image of the One, infused as John the Beloved wrote, with "the true light that enlightens everyone coming into the world?" I am reminded of the royal garments of ages past, woven through with a single golden thread that, if

removed, would cause them to unravel. Is not the Godhead hidden at the core of us the golden thread that weaves throughout our being? Wouldn't we unravel should It vanish? Our very presence, like the existence of those living off in far-flung jungles or on isolated mountains, proves our connection to that same Source, does it not?

The flat crown atop the nearby Table Rock is a nesting ground and wildlife refuge crowded with cormorants, gulls and tufted puffins. The latter has become a sort of mascot for the village, spotted everywhere from banners to "no puffin" signs taped in nonsmoking restaurants. I feel most alignment with the cormorant, fishing below the surf at dusk. It seems a perfect symbol of the pilgrim's quest, the path through dark unknowing based on trust alone.

Questing by starlight,
Cormorants plunge into the sea,
Into the dark night.

I meet the Bandon Bird Man, who monitors the refuge through the telescope on his deck. In his back yard are mini-versions of my yurt where he nurses injured raptors until they're strong enough to be set free. A blind pygmy

owl hunkers on a perch inside his home, unmoving as it eavesdrops on our conversation.

He takes me with him while he frees a mended bird. As the barn owl glides into the trees, crows caw their outrage at the killer in their midst. The owl will speak its piece come sunset and the crows will then be grateful for their feathers black as night.

The shorebirds share the ocean's bounty with the people of the coast. I write this journal sitting on the jetty for several afternoons, while young boys swing long lines into the river, yanking 3-pronged jigs through schools of tiny smelt making their annual upstream run. With each jerk of a jig and each fish snagged, their mothers' frying pans grow fuller.

> Smelt throng the currents,
> Racing with the inbound tide,
> Running for their lives.

Nature is a generous provider where the waters meet the shore. While jiggers ply the river, diggers sift the sand for razor clams. Crab pots are raised and lowered from the docks while fishers reel in red-tailed perch from the surf. Fluid harbor seals slide like distractions through the chop

and sometimes snatch the flopping quarry for themselves. Each day at dusk, dinghies packed with crabs and trawlers full of salmon, perch and whitefish unload their catch at the Bandon Cannery. This is easily the ripest site in town; I am grateful that I live with my thoughts, rather than with a cannery worker.

> Broken coral claws ...
> Crab shakers squeeze sea-scented flesh
> From fermented fingers.

Everywhere are signs of spring — skunks emerge from winter hibernation, humanity from torpid dormancy. Plants send up new shoots and townsfolk smile more readily, transformed by sunshine and the seasonal rebirth. Even the final, warmer showers are welcome, harbingers as they are of new growth and the return of annual guests — swallows and robins, and for the business owners, tourists.

> This bare cherry tree
> Seemed dead, but here in April,
> Opens ruddy buds.

> After winter's deluge,
> Buds thrust through thawing mud,
> The snow-white crocus.

Orange poppies blaze
Across the hills, scattering
Sparks of daffodils.

Tap-dancing in new grass,
Mimicking the melody of rain,
A robin cocks his head.

Slicing the wide sky,
Swallows seek their summer homes,
This first April day.

Rachel the Bandon Storyteller returns from a year in Wales with new fables for the young ones of the village. She now adds to her credits: "internationally renowned."

> The storyteller
> Spreads her arms across the seas.
> Tales from everywhere.

One from village history tells how the town burned to the ground almost a century before, the devastating fire fanned by a stiff north wind and fueled by oily gorse. The thorny furze was a useful hedge in the founders' native Ireland, but in Bandon spread unchecked throughout the town and all across the cliffs that front the beach.

The village is more thorough now at eradicating gorse, but the shrub still thrives on headlands and displays a brilliant bloom each spring. I delay the next steps of my journey just to see this annual show.

> Overwhelmed by gorse!
> Yashmak of yellow petals
> Veils its oily thorns.

The wind shifts and the days are drier. I happen on a sudden burst of color in the sky above the beach — kites of every shape and size and decoration. From what hiding place did they spring so unexpectedly? Christmas gifts, perhaps, ordered from a catalog, buried in boxes, waiting all these months to spread their wings.

A vacant April sky,
Suddenly alive, dancing
With paper rainbows.

A butterfly kite,
Yields to an upsweep breeze and
Brushes heaven's cheek.

With warmer weather, the beach is besieged by hordes of children toting shovels and pails, raising sand castles and sculptures everywhere. Their toil creates a temporary township, yet no more lasting than cloud castles in the air.

A playtime village.
Castles of sand slide seaward with
The unfeeling tide.

By April's school break visitors, in massive herds of motor homes, are filing north through the village. They tour the cranberry bogs that surround it, shop the stores, the cheese and candy factories, and finally fill the campsites at

Bullard's Beach. Anders needs my yurt and I have a chance to practice letting go. It was a wondrous gift but, like all loans, transitory. My hermitage for the next phase of my journey will be my tiny tent or, on dry nights, the immensity of star-filled skies.

Four months have passed — like the Athabascans, like the reflection of the moon on ocean waves, gone with barely a trace. It's time again to strap on my pack. One glorious morning I leave the campground with a handshake for Anders and a parting nod to that sinking moon, prepared to track the summer season inland.

Summer

Hiking into the rising sun with a radiance of ocher billows overhead, I follow the south shore of the river, entertained by choruses of frogs. The stream as it passes speaks to those who care to listen. It reminds me we are mostly water, how like water we must learn to flow — not violently but yielding, around the rocks and blockages obstructing us. And when the blockage is high and wide, how we must deepen and build our reserves until we finally can crest or erode it with our new-found strength. Thus the river imitates the Zen practitioner's attitude toward the world: first it opposes barriers, then resigns itself, cooperates with its opposition, and finally directs, moving from passive to active partnership with the rest of nature.

> Frogs fall silent,
> Gazing with grave black eyes
> From the river mud.

> When I flow lightly
> As the brilliant river,
> The frogs keep singing.
>
> Bullfrog croaks *knee-deep*,
> Calling smaller frogs to tea.
> They are the crumpets.

From habit now, I scan the shore for spear points and other signs of those who plied the river centuries or merely years ago. The marshes and the estuaries fed newly-come families in the great depression of the 1930s, long after the native tribes were gone. Many of these later migrants settled in the region, alongside airmen sent to guard the coast during the Great Pacific War. A Japanese team floated one bomb, carried by balloons, that came down almost unnoticed outside a rural town.

Every few miles are signs of settlement, past and present, and impermanence. An abandoned lumber mill beside the water murmurs of a bygone era when the river was a major means of transportation. A cluster of homes with matching roofs huddle around a half-complete marina. They tell of an investor's pipe dream, a resort for yachtsmen that never met its promise as a world-class destination. Money was lost, hard lessons learned, but the residents all got new blue

roofs. From a nearby height you scarce can see the shacks beneath.

Buson, Village

The stream glides silently between its banks. The elevation of the land beyond the non-marina is only slightly higher than the ocean beaches. When the tide rises, its current drives the river backwards, a ballet of fresh and briny water. Dragonflies are partners in the dance and, several meters from the bank, the fluttering butterflies.

> Rising ocean tides
> Finally ebb and so embrace
> The stream that feeds it.

The lush fields through which I hike, fertilized by winter flooding, are ideal for raising dairy cows. The milk of the animals I meet supplies a nearby cheese cooperative. Rye wheat for the following winter grows undisturbed in neighboring fields. The dairy farms are modern, and the fawn-and-white Guernseys are at peace, outside time, the windblown grass their pastoral meditation. They plod at dusk to their milking barns and I settle for the night by the river's edge.

> Swollen by spring rain
> The river mother suckles
> Pasture grass and cattle.

> Rye-grass pastureland.
> The river zig and zags
> Past a grazing calf.

This calf recalls for me the story of a seeker who once asked the Sacred Cow the secret of enlightenment. She answered "Mu," the ideogram for "no-thing." Alas, the

pilgrim knew no Chinese and so left disappointed. Issa wrote:

> *Ushi mō, mō mō to kiri kara detari keri*
>> The cow appears
>> Mu-u! Mu-u!
>> From within the mist.

Had the young man understood the Sacred Cow, he might have cleared the mist of ignorance, like the lizard I chance upon as I near another village.

>> Lazing in sunshine,
>> This lizard wants no-thing,
>> And lacks no-thing.

>> On the sunbaked head
>> Of a myrtlewood Buddha
>> Lizard found nirvana.

This gathering of houses hovers above the river. I talk to a chainsaw sculptor who carves tables of redwood burl gathered from the beach, bears rising on their hind legs, more in surprise than menace judging from their blank expression — along with frozen native warriors in stiff poses.

The chainsaw is a crude tool for such whittling. To define a mien elusive as the fire in a grizzly's eyes or the snarl arising in his throat is scarcely possible. Yet the man says that he sells a few wares each week from his carvings spread beside the highway to the coast.

While we speak, his wife bends to her tasks in the garden beside their clapboard house. She passes with a basketful of food, head down, eyes lowered, her face mostly hidden by her long hair and straw bonnet. She is small and slim, slope-shouldered, the physical opposite of her burly mate. She is as still as he is talkative and her spirit seems as heavy as her load. My own heart feels heavier as I watch her disappear through the

back door of their home. I take leave of her husband and shuffle down the road.

> The carver's bowed wife,
> Though she rises from her work,
> Seems still on her knees.

I am thankful to be near the river as the afternoons grow warm. I spend my middays meditating in the shade beside the stream, dangling unshod feet in the water. I learn that rabbits startle far more easily than deer and that kingfishers seldom rest from their patrols. The vines along the bank are already flush with blackberries. The fruit is hard and green, though, leaving me longing for August.

Large shadows cross the path as I walk. Noiselessly the vultures wheel above me, going about their gleaning, nature's undertakers. They ignore my ambulation, searching rather for casualties of the night to nourish their carrion patrol. In the natural cycle, each creature feeds another, so that even our deaths nourish the living, whether they be microbes or maggots, jackals or these buzzards.

> Circling vultures gyre
> Until they spy the secret
> Hidden in the weeds.

> A startled buzzard
> Screams skyward, its cry like laughter,
> Wild and dark as death.

I cross a mile-long levee to the city of Coquille, pausing only for a sandwich in a redesigned caboose. The city's name, *shell* in French, reminds me of symbolic shells displayed by pilgrims on the Spanish path to Compostele and the shrine of Santiago (St. James). One route begins in southern France, where they might enjoy Coquille Saint-Jacques before they leave.

Many whom I pass in this town seem suspicious of the stranger in their midst. I move through quickly, thinking of the Bird-Man's barn owl and the crows that wished to caw it off, and of the Bandon pioneers and their Athabascan neighbors. Distrust of "others" seems a universal fear.

Some miles beyond, I happen on a place with a surprising name — Norway — no doubt the smallest Norway in the world. I wonder if this spot is even judged a town by the postal service, for in fact it is no more than a run-down sawmill and a few old houses clustered by the road. Beyond and below the buildings are rich fields and grazing herds as far as one can see. Egrets stalk among them in a symbiotic stroll.

Strutting like herdsmen —
Cattle egrets, like blown cotton,
Dot the pea green pasture.

The next town, Myrtle Point, is as busy as Coquille, but this I quickly learn, is a once-a-year event. The county fair has hit the village, and everywhere one scents its carnival air. It's the highlight and the lone excitement of their year.

Overwhelmed by crowds and so much energy, I keep hiking and, a few miles down the highway, take a detour to the south. In three days I reach the logging town of Powers — just in time for the tiny hamlet's own mid-summer celebration. This festivity is smaller and more calm than the one I left in Myrtle Point, and I stay to take it in.

The following day begins with a 10K race. The tense excitement of the runners come from nearby towns is catching, and I choose to join the pack. A school bus leaking diesel fumes hauls us up a mountain past the town, so that the scamper back is all downhill. Competitors are thrilled as nearly all set personal best times for the distance. A feast of sliced fruit, juice and water at the finish caps the perfect run.

> Stampeding runners
> Startle even mule deer, though
> The deer are quicker.

With the last runner in, a parade begins. Four floats on flatbed trucks, several flocks of grade-school children and a bevy of bikes circle in a figure eight around the two blocks

of the town so the whole parade passes waving watchers several times, making up in repetition what it lacks in length.

A fellow runner offers me a ride back to the highway, saving me a three-day hike the way I came. Time means nothing, but I seek new sights. I decline his further offer of a place to sleep, as I've come to love the nights beneath the stars. In the blackness of wide skies they seem almost in reach, the vastness of the night a mirror of the vastness of my spirit. The silence is broken only by chirping crickets, the rasping hum of cicadas and the rustling of night feeders foraging in the trees. Floating in this space while my body seems to sink into the soil beneath, it is easy to imagine one is wholly spirit or wholly earth, outside the confines of the human shell.

>	A cosmic chorus,
>	Stars warbling like nightingales.
>	Midsummer nocturne.

>	Bats zip, dip and dart,
>	Fluttering without a sound —
>	Midnight butterflies.

Limitless cosmos.

Our vast and limitless spirits.

Who can divide them?

Following a fork of the river, I pass through a series of small outposts: Bridge, Remote and Camas Valley. Each affords a small café, convenience store or gas pump, backed by farms or vineyards. They rise like stairs up the tributary that climbs into the range of mountains separating the coast from the inland corridor.

Sesshyu, Amanohasidatezu

The hike is hot work with my pack. The elation of the first days of summer wears thin as the afternoons heat up and

the path grows steep. But the sweat soaking my shirt is also a teaching: only when the first fervor of awakening has passed does the genuine work of transformation begin. The climb becomes a meditation on patience and perseverance.

I set up camp for several weeks at the Bear Creek rest stop near the headwaters of the Coquille. The landscape is rugged and forested, and the cover of Douglas fir offers welcome shade from the heat. The days are scorching now, even at elevation, and I decide to wait out the hottest of them here among the trees. The river has diminished to a bubbling feeder creek here, close to its source, and its song both soothes and energizes.

Chang Feng, Meditator

I've hiked the life span of the river in reverse — from the deep maturity of old age when it disappears into the salt sea, back to the froth and turbulence of its birth and adolescence. I've encountered water in myriad forms on this journey — as rain, fog, drizzle, mist, as slough, creek,

river, waterfall and ocean — each form different, yet the same, true always to its water nature. Just so are the billions of manifestations of the Divine in our world of forms; just so, immutably the same.

A narrow bridge arches high above the creek, leading to a trail that ends finally in a clearing. I pitch my tent and here relax most of the daylight hours. The clearing is a comfortable remove from the larger park, the tables and portable privies that host the flow of motorists. Their chatter and shouts surrender to the hooting owls at night, a soothing backdrop for easing into sleep or stargazing on the bridge.

> Cicadas churr
> So stridently I can't hear
> The neighbors quarrel.

> Gliding through moonlight
> Pairs of spotted fawns are
> Dappled as the leaves.

> A final *hoo hoo*.
> The owl's farewell to light
> And the dawning sun.

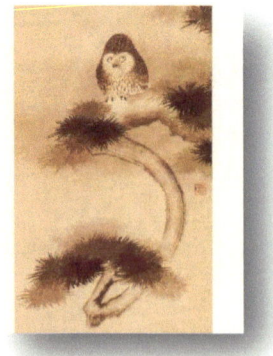

Sansetsu, Owl on a Pine

In mid-September I strike camp, on the move again. I'm well rested, but low on supplies. With another day of climbing I crest the Coast Range and begin the long descent toward the corridor and freeway that bisects Oregon north to south. I restock in Tenmile, another of the blips that dot the road to and from the coast. "Ten miles from what?" The man behind the counter only shrugs and runs to fuel a pickup at the pump outside his store.

The way is blessedly flat for a stretch of several miles along a fence line that seems to border a single ranch. Clumps of cattle watch from fields or stands of oaks, but I see no house or human in all this sweep. It ends at Brockway, which again seems but a name painted on a general store. If this is a community, it is subtle beyond understanding.

This crossroads enterprise, a two-story clapboard building in the midst of nowhere, carries clothing and farm supplies along with food. Out back is a stack of hay. It is run by a young couple newly moved from California, and their tired, sad eyes confess they've bought an inescapable mistake, a daydream soured by a cumulus of realism. I buy a tin of bag balm for a blister on my heel and wish them well, hoping they will find some silver lining in their disappointment.

At the Brockway store I finally leave the two-lane that I've followed from the coast, turning toward Dillard and the old highway to the south, the main route in the days before the interstate. I've no wish to hike the freeway with its haze of diesel fumes.

I connect with the old road at a still-thriving lumber mill and rest awhile beside a cooling pond. Pipes from the factory splay beneath the sprays of water, while dunes of sawdust rise behind the sheds. Haphazard heaps of soaked logs sit opposite neat stacks of finished boards, the "rough and ready" phases of the milling process. Pickups fill the parking lot.

In the weeds next to the pond I spy a nearly vacant, weather-beaten seat in the shade beneath a maple. I say *nearly* vacant, for nature has done her best to reclaim it as her own.

> Morning glories
> With the gentlest embrace twine
> Up this weathered bench.

I take a sandwich from my pack, thinking once more of Matsuo Bashō. On the same sheet of paper on which he

sketched a gentle *haiga* of a morning glory moist with dew, the erstwhile samurai wrote:

> *Asagao ni ware wa meshi kū otoko kana*
>
> I am one
> Who eats breakfast while gazing
> On morning glories.

While reveling in the same gaze as the poet, I savor my sandwich. Then, with a grateful backward glance, I bid farewell to summer and rush to join the geese and swallows in their annual migration, soaring southward.

Buson, Bashō in Meditation

I've covered only ninety miles in the nine months since I left Cape Blanco, plus the eighty-mile diversion trip to Powers, distances a car could span in several hours. But time, in its small entities of seconds, minutes, days and even weeks, has lost its meaning in this nomad world. I've become a creature and disciple of the seasons. There is only

now, this fleeting instant, and it has vanished in an eyeblink.

> North wind at my back,
> Single-minded as these geese,
> I take wing from summer.

The Hundred Geese, attributed to Ma_Fen

Autumn

As I leave the wigwam kilns of the lumber mill, I am struck by the connectedness of human enterprise. Loggers cutting and bucking trees, mill workers planing the finished boards, builders, painters and roofers raising new homes, banks tendering money to house buyers and through them to furniture movers, utility companies, communities of grocers and other vendors — all strands of the commercial web.

What a wondrous age would burst upon the earth if the mystic force should ever infiltrate this web, transforming it into a network of love and kindness. The world could do away with courts and laws, for none would cheat his neighbor or his client in compassionate trade. Free enterprise would find its heart.

>In my crystal dream
>The whole earth shines radiant
>As fire-tried souls.

>I wake from dreaming.
>Below my open window
>Children skip and sing.

> A finch chants sweetly
> On a stem of ripened wheat.
> Both flash crowns of gold.

My endpoint as I enter fall is Oregon's Rogue Valley. The weather there is bearable even in the coldest months, a Mecca of sorts for those who by choice or chance lack indoor shelter. Rainfall is one-fourth that of the coastal zone where I spent last winter. I have a hundred miles and four mountain passes yet to cross before I settle there.

Keeping to the old highway south beneath a cloudless sky, the first community I come to is a second named for the Myrtlewood tree. The coast had its Myrtle Point, this inland route, Myrtle Creek. It's the first town I've entered in several months with more than a convenience store.

Wandering through its streets creates an odd dislodgment, the way a Nepalese Sherpa might feel should he suddenly find himself in central Kathmandu. Shedding the sensation, I cut through a vacant field to a grove of trees.

In their shade I'm suddenly struck dumb, a hush that wells from deeper than my ordinary calm. Rather than entering the woods, I feel the trees have gathered round me, their peaceful energy as they sense me through their leaves and

bark, their roots, tendrils, limbs. They are guardians, they say — from the wise and lofty grandparents to the younglings that rise only to my knees — sent to protect and serve us, to soothe us with their beauty and to cleanse the air we breathe. The old and gnarled with missing limbs and scoured trunks are as splendid as their tallest, most majestic kin — just as with aging humans once we see the loveliness in each.

Rokuso Gohei asked on entering Bashō's hermitage: "What is the Buddha nature of this tranquil garden with its trees and grasses?" The poet replied, "Large leaves are large, little ones are little."

Shen Zhou, Chanting Poems Among Pines

> Trees return my gaze,
> Spying with the selfsame eye
> With which I see them.

Above the dun weeds,
A rabbit's cocked ear. Can it
Hear my silent soul?

Pausing on my knee,
Fanning its lavish wings,
A fearless butterfly.

The mosquito's prick
Left no itch, no swollen trace.
What is this wonder?

South of Myrtle Creek a titillating sign beckons from a highway exit toward a town called Riddle. The name is tempting, but I resist the urge to unravel its question. It lies

six miles off my course and my southward focus has become unshakeable. Months on the road with autumn fast upon me are urging me to find a den, a place where I can hunker through the introspective nights of winter. I must respect the changing of the seasons, even as I embrace the cycles of my life.

A moment's entertainment comes when I round a half-dome hill beside the road. The view opens to a tiny valley orchard. A bear sow leads three cubs through the trees, but with such deliberate progress that I feel my eyes are playing tricks. It is a trick, in fact, an illusion to tickle passing drivers. The bears are black metal silhouettes.

I mentally thank the farmer for his sense of humor and for lessening my trek. At the same time, I am disappointed that they are not actual bears.

> Which are more real, these
> Metal bears or curious cubs,
> All wrought from molecules.

I'm forced for a time to follow the main interstate. I've returned to civilization. The towns along the corridor are larger and more numerous. The mass of cars and trucks, and the speeds at which they hurry past, shriek of a frenetic mindset I thought I'd left forever. I'm glad to be on foot, traveling at a measured pace, and recall a former scene — an old monk moving mindfully, begging through the sidewalks of Mumbai. Another memory, of Nicaragua, a rude awakening in a jungle rimming a water-filled volcano:

> Howler monkey mobs
> Screech through tropical dreams,
> Banshees in the heat.

Arriving in Canyonville late evening, I'm treated to a huge orange harvest moon at rest on the horizon. I restock supplies, for no towns lie in the mountain pass ahead.

> In its limbs the Pine
> Cradles the plump moon,
> Until it needs leap free.

Ong Schan Tchow, Pine In Moonlight

> Awakening even the
> Ancient moon, the coarse refrain
> Of the cicada.

Climbing through the passes with a heavier, food-jammed pack, still avoiding the warmest hours of the days, I need almost a week to reach Wolf Creek. With the hard part of the journey now behind me, I celebrate and treat myself to an overnight room, hot meal, soft bed and shower in an historic inn. A few foothills remain, but they will need but an hour each to cross.

I look forward to Grants Pass, for it marks the northern fringe of the Rogue Valley. The highway to and through the valley is strung with towns like prayer beads, their names describing the beauty, history and magical mood of the area: Azalea, Sunny Valley, Merlin, Rogue River, Gold

Hill, Medford (Middle Ford), then Phoenix, Talent and, finally, Ashland, where I arrive on the fifteenth of October.

For several days I camp in a corner of the city park, in the woods beyond the public trails, enjoying the rush of a nearby creek and the hint of autumn color. The park has two ponds, one with an island sanctuary for nesting ducks and turtles, the other featuring a pair of white swans downhill from a theater called Black Swan. Something is amiss. Perhaps I am disappointed that the swans aren't black, but still I marvel at their elegant motion. Of course their graceful glide demands a flurry of pedaling beneath the surface. Life is often not as it appears.

In the park one afternoon I meet a couple. We talk awhile and they invite me to their home. I accept for this will surely be another learning opportunity.

We wander after dinner through their garden to a guest house at the back edge of their land. They tell me they are leaving soon for San Diego as they have no love for winter. Would I like to live in the cottage and watch their property while they are gone?

Buson, Hut with Bashō and Owner

Again the universe has smiled on me, as with the yurt in Bandon. For the second winter in a row I'll have shelter from the cold. This secluded spot should be ideal for prayer and contemplation, solitude and silence.

Once I've settled in I learn that trails through a nearby forest lead to a waterfall, a peaceful place for walking and standing meditation, empowerment tools of the warrior monk. These woods cling stubbornly to summer. Trees and shrubbery vibrant with light enfold me in a luminescent green cocoon.

> Early autumn leaves,
> Pendants green as tourmaline,
> Radiant as jade.

A green cathedral,
Flaming candles everywhere,
Wild red strawberries!

Kneeling in soft moss
I reached to pluck a violet,
But my soul said, "No!"

Dragonflies mating
On the handrail of a bridge.
Rhythmic waterfall.

The symphony of the cascade tumbling from various heights resonates like the chanting of Tibetan monks. It finally drops into a lucid pool where it builds behind a logjam dam. From there it seeps into a narrow creek that I can leap, like a superman, in a single bound.

The waterfall and pool at its base bring to my mind the grace and light poured constantly into the clear, original soul. There they are dammed by the busy mind, and the merest trickle of love passes through to the outside world. Obstacles of fear or neediness, anger, envy or greed restrict the flow of our highest Self. The poet Milarepa wrote of such illusions:

> See demons as demons: that is the danger.
> Know that they are powerless: that is the way.
> Understand them for what they are: that is deliverance.
> Recognize them as your father and mother: that is their end.
> Realize they are creations of the mind:
> they become its glory.
> When these truths are known, all is liberation.

Embracing both demons and benevolent spirits seems to be the theme these autumn weeks. As I become familiar with the town, teachers emerge from unexpected places — women in their wisdom years, a Hindu x-ray technician, street people and Shamanic healers, coffee shop philosophers, gemstone and aroma therapists. Here are lessons to be learned in right intention, authenticity, respect for boundaries, speaking truth and sensitivity to a range of energies — in short, how boundless beings adapt to life while yet confined in the chaos of the human brain.

The seemingly miraculous nature of this town, once one opens to its wonder, is astounding, and even penetrates my dreams. In one I am embraced by the Divine Mother and gaze into her compassionate face — call her Sophia, Quan Yin, Holy Spirit, Wisdom. As I nestle childlike in her arms, I feel nurturing I've missed for years.

How can she be
The context of Pure Love
With so much to mind?

The pulse of drumming in another dream sends a hot rush surging through me, stronger than any flow I've known in seated contemplation, literally head to toe. A wise friend suggests I'm being tuned for something. No more fiddling around.

Next is Niwakusan, a white-haired man I meet in vision at the trailhead of the woods, a healer and a teacher of deep magic. While I sleep he tells me I must open up my heart to what is closed, soften what has hardened to obstruction, how to let pain out and healing in, how to melt the shell that holds the world at bay.

His call is followed by a caravan of creatures. A pair of great blue herons, my old friends, lift from the ditch beside my hut. Grey fox trots through a field above me, pauses for a long and silent observation, then leads me to the trailhead of my dream, where it disappears among the trees. On a vision quest, I seek a desert dweller (although I'm hiking in the mountains), and a Madagascar Giant Gecko scuttles off the trail. It waits beside the path, even when I squat to talk. This is no local reptile, and its lack of fear makes me think it once was some child's pet — or maybe just Niwakusan at play.

Through all these serendipitous days, I see glimpses of the coming change in weather and look forward to the months of hoped-for inner transformation. November looms as I record another birthday, another milepost on the road toward home.

Last leaf on the tree,
Sober as a rotund crow
Puffed against the cold.

Buson, Winter Crows

> This grey, aging snag
> Can't stay the insistent wind
> Clapping its branches.

I ponder the now-drab leaves drifting in a creek. Gazing on this scene with love and gratitude reshapes the world, I know. These leaves, this water, are linked in their intrinsic nature to all the other tumbling leaves and water in the world. Someone somewhere, gazing on a floating leaf, is sharing this same thought.

> This solitary leaf,
> Twirling free, yielding to earth,
> Renews the world.

> A departing leaf
> Fell into this brook, sailing
> For plant Valhalla.

Come spring I may continue eastward to Mount Mazama, Crater Lake and Oregon's high desert — volcano country. But for now, I am at peace inside my cottage, waiting for approaching winter and the scent of snow, exploring the town below, eager to learn what I can from whom I can, be they animal, spirit or human teachers. This student is ready!

A whistling kettle,
Sacred texts by lamplight,
The year's longest night.

How I long to see
The first snow on Mount Ashland!
Gray mist veils the peak.

As the old year ends,
I feel my pilgrimage
Has just begun.

Kano Sansetsu, Yuimakoji-zu

Ω

Author Biography

John Richard Sack grew up in Ohio and Kentucky. He has a BA in English from Yale University and an MA in Creative Writing from the University of Washington.

As a young man, John lived as a Trappist at Our Lady of Gethsemane Abbey in Kentucky where Thomas Merton was his novice master. He later trained in a Hindu ashram in Ganeshpuri, India. Spiritual awakening and transformation are common themes in his books.

He is the author of the internationally-acclaimed novel *The Franciscan Conspiracy*, published in 17 languages, and a companion work, *Angel's Passage*. *The Wolf in Winter* is a tale of the early career of Francis of Assisi. *Trappist Tales* is a collection of short stories set in a fictional abbey. His nonfiction books, *Yearning for the Father* and *Mystic Mountain*, are maps for the contemplative journey.

John currently shares *Casa Chiara Hermitage* on a mountainside in southern Oregon with his wife, author Christin Lore Weber.

www.ingramcontent.com/pod-product-compliance
Lightning Source LLC
Chambersburg PA
CBHW040907180526
45159CB00010BA/2958